G000038933

TRAVELER'S ADVISORY

JESSICA LEHRER, RICK LIGHTSTONE & ALICE MURRAY

MARK BATTY PUBLISHER · NEW YORK CITY

Dear Reader,

Traveling is a concept sold to the general public as an escape from worry, a freedom from care, an entry into paradise.

Those of you with more travel experience know that too many people venture out into the unknown world oblivious of the dangers and pitfalls lurking around every corner.

Rest assured: the international staff of researchers at the Traveler's Advisory has explored and examined every aspect and ramification of global passage-making: by land, air and water; at higher and lower altitudes, latitudes and longitudes; with or without the help of a so-called guide.

As one famous travel writer once said, "Having a travel adventure is a life-enhancing experience, but only if you don't wind up dead."

The pages of this book contain only suggestions. Those of you who wish to visit, for example, an active nuclear plant, or place themselves on the front lines of armed conflict, do so at their own risk.

Can this advisory save (the rest of) you from injury, despair, food poisoning, imprisonment and loss of life? Perhaps. Then again, maybe not.*

In conclusion: traveling is an activity that should be taken seriously. Very seriously. Read this book and travel confidently, knowing that you have been advised.

 Sincerely,
The Traveler's Advisory

*The authors take no responsibility for anything negative that happens to you while abroad: whether before, after or while reading the Traveler's Advisory. However, if the advice contained in this book turns out to be fortuitous, we assume full credit.

WEATHER FORECAST:

**SUNNY AND WARM
BEFORE YOU ARRIVE.**

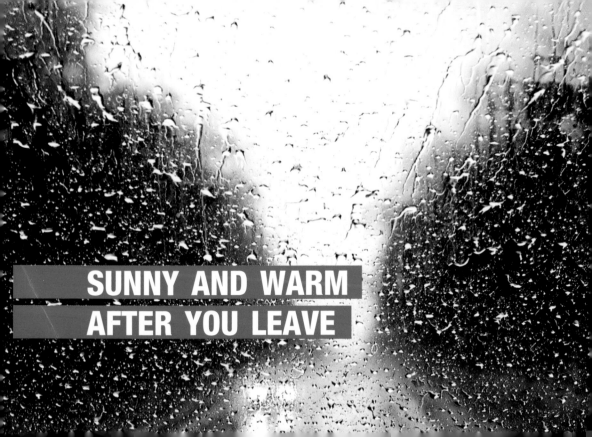

DENTAL PRACTICES
MAY VARY

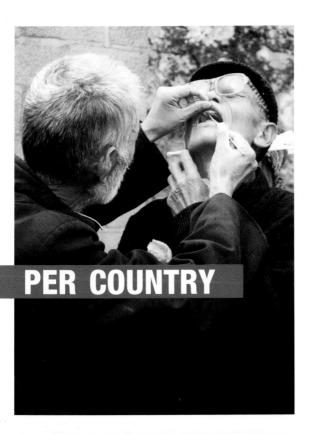

PER COUNTRY

LAUNDROMATS ARE
NOT AVAILABLE IN

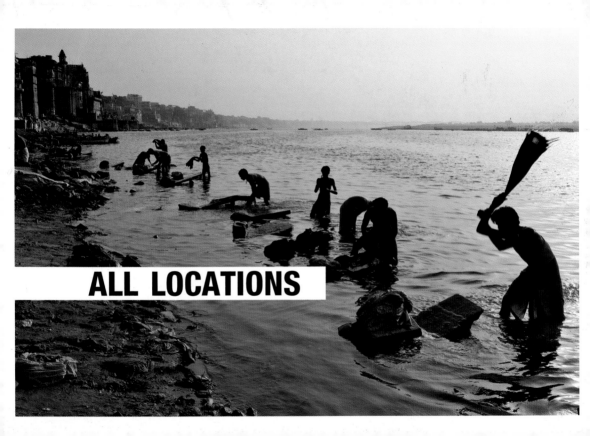

ALL LOCATIONS

TRAVEL BROCHURES

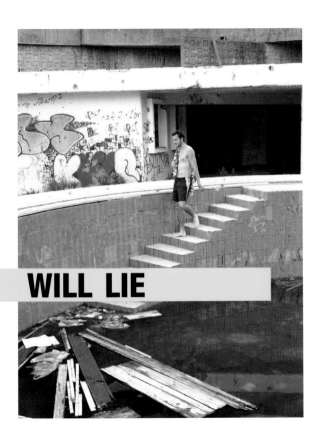

WILL LIE

CHECK

THE BUS SCHEDULES

CAREFULLY

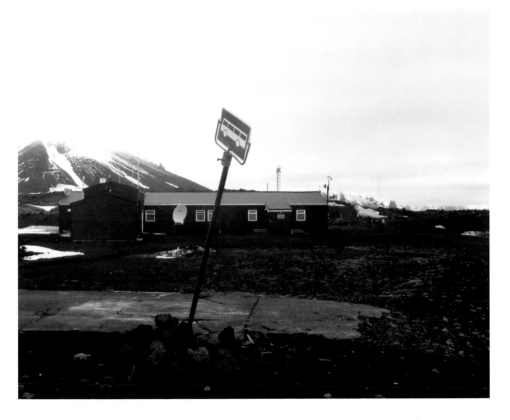

MAINTAIN A SENSE OF

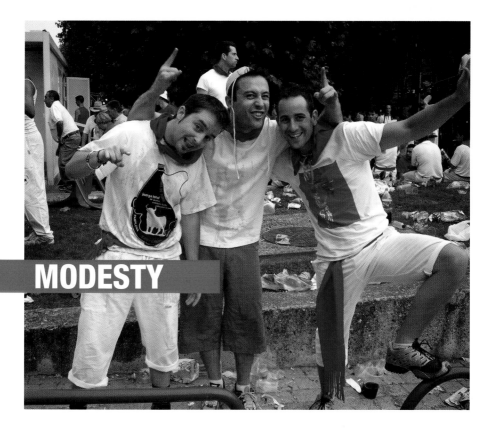

MODESTY

TIPPING IS ARBITRARY...

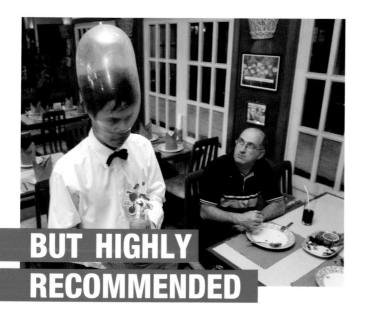

BUT HIGHLY
RECOMMENDED

DIFFERENT COUNTRY,
SAME SOLAR SYSTEM

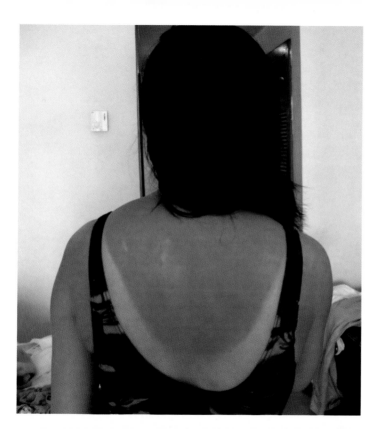

SOME COUNTRIES DRIVE
ON THE
OF THE ROAD
THE REST OF US
DRIVE ON

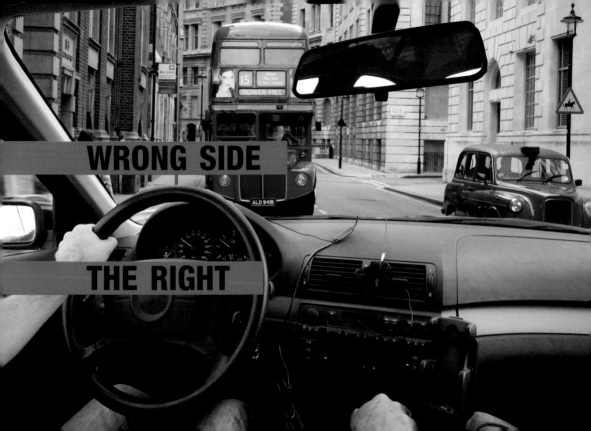

RELATIONSHIPS AND TRAVEL ENOUGH SAID.

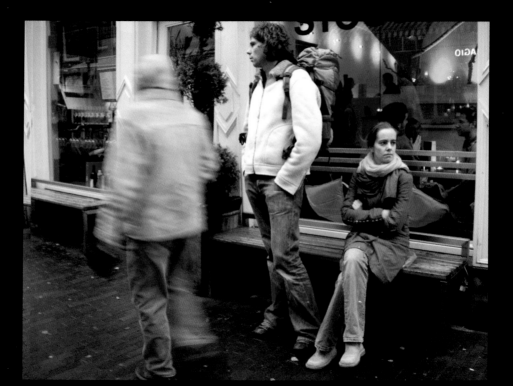

LEARN TO RECOGNIZE
THE EARLY WARNING SIGNS
OF CIVIL UNREST

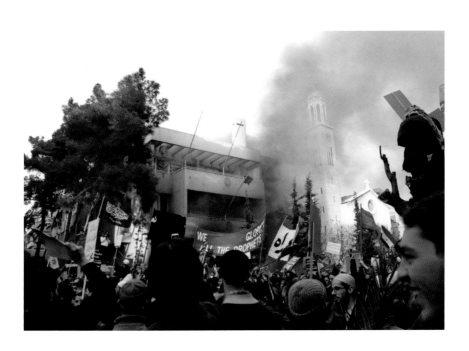

THE BEST WAY TO
GET FROM POINT
A TO POINT B
IS TO ASK AT EVERY CORNER

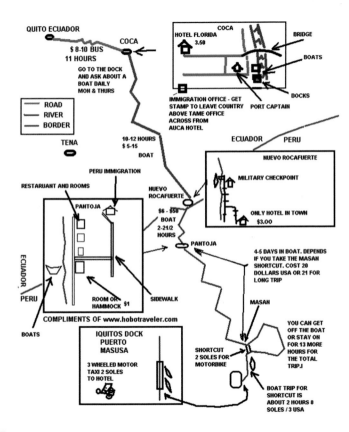

QUITO ECUADOR

$ 8-10 BUS
11 HOURS

COCA

GO TO THE DOCK
AND ASK ABOUT A
BOAT DAILY
MON & THURS

| ROAD |
| RIVER |
| BORDER |

TENA

10-12 HOURS
$ 5-15
BOAT

COCA

HOTEL FLORIDA
3.50

BRIDGE

BOATS

DOCKS

IMMIGRATION OFFICE - GET
STAMP TO LEAVE COUNTRY
ABOVE TAME OFFICE
ACROSS FROM
AUCA HOTEL

PORT CAPTAIN

ECUADOR PERU

NUEVO ROCAFUERTE

MILITARY CHECKPOINT

ONLY HOTEL IN TOWN
$3.00

PERU IMMIGRATION

RESTARUANT AND ROOMS

PANTOJA

**NUEVO
ROCAFUERTE**

$6 - $50
BOAT
2-2 1/2
HOURS

PANTOJA

4-5 DAYS IN BOAT. DEPENDS
IF YOU TAKE THE MASAN
SHORTCUT. COST 20
DOLLARS USA OR 21 FOR
LONG TRIP

ECUADOR

PERU

ROOM OR
HAMMOCK $1

SIDEWALK

MASAN

YOU CAN GET
OFF THE BOAT
OR STAY ON
FOR 13 MORE
HOURS FOR
THE TOTAL
TRIP.I

COMPLIMENTS OF www.hobotraveler.com

BOATS

**IQUITOS DOCK
PUERTO
MASUSA**

3 WHEELED MOTOR
TAXI 2 SOLES
TO HOTEL

SHORTCUT
2 SOLES FOR
MOTORBIKE

BOAT TRIP FOR
SHORTCUT IS
ABOUT 2 HOURS 8
SOLES / 3 USA

STICK TO YOUR TRAVEL BUDGET

STAY ON GOOD TERMS WITH YOUR (WEALTHIEST)

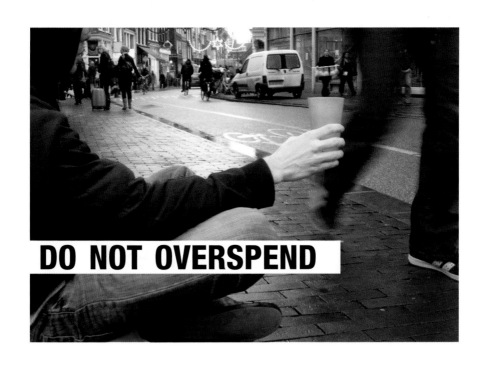

DO NOT OVERSPEND

SOME VEHICLES MAY NOT MEET YOUR PERSONAL SAFETY STANDARDS...

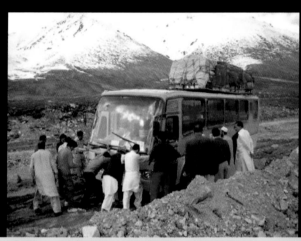

OR ANY FOR THAT MATTER

THERE ARE DIFFERENT KINDS OF CAMPSITES...

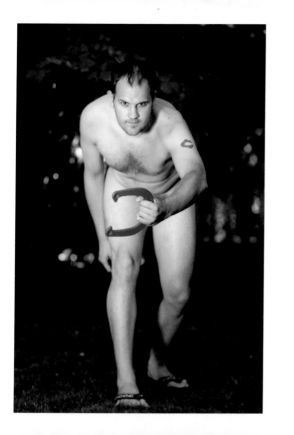

...AND DIFFERENT
KINDS OF CAMPERS

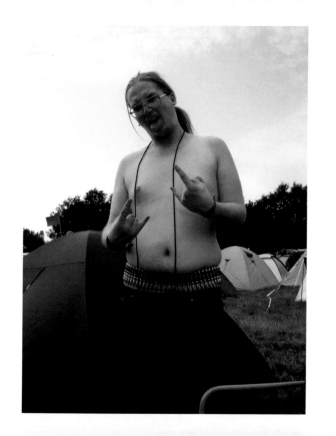

ALWAYS CARRY

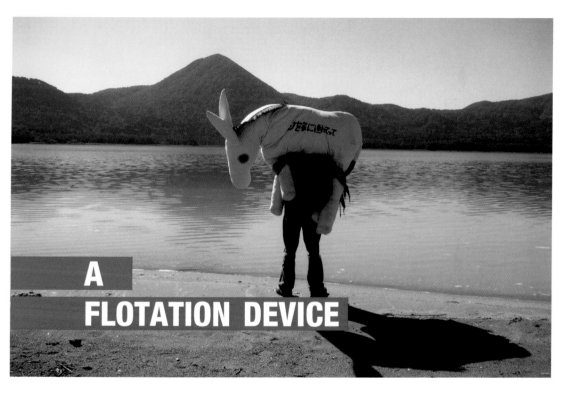

A

FLOTATION DEVICE

EMBRACE YOUR
INDIVIDUALITY

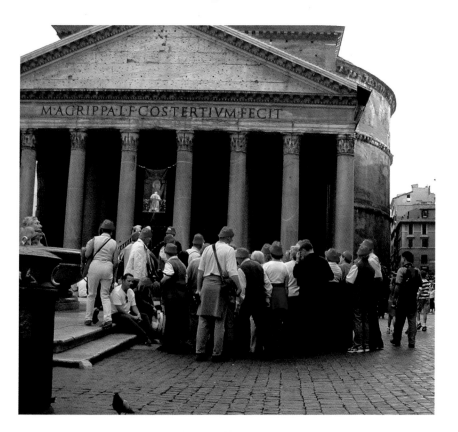

TAKE YOUR JOURNAL EVERYWHERE YOU GO...

...YOU MIGHT NEED THE PAPER

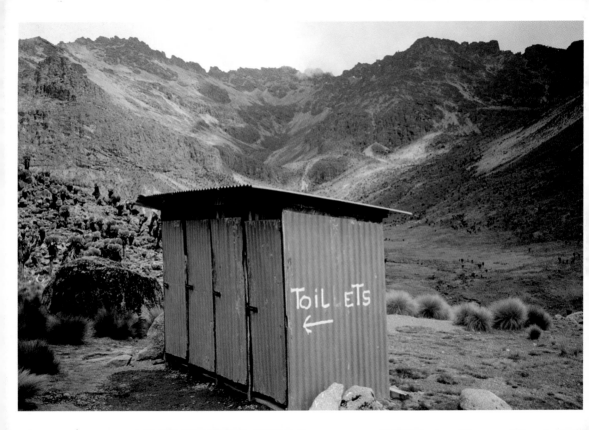

MAKE SURE THE WATER IS

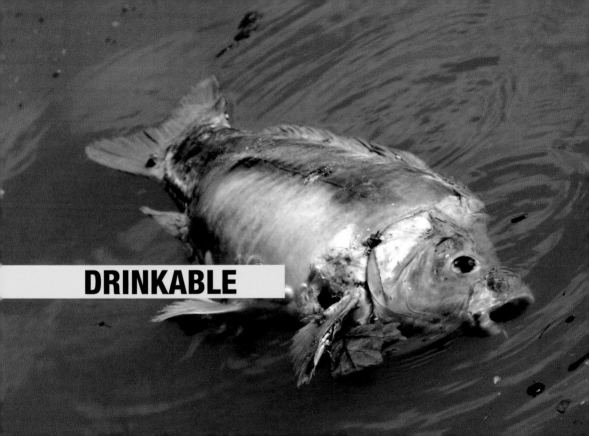

DRINKABLE

IF YOU HATE
THE ITALIANS...

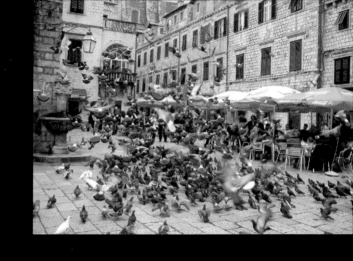

FEED THE PIGEONS

BE COOL

BE ASSERTIVE

REACT PROMPTLY

CALCULATE YOUR ODDS

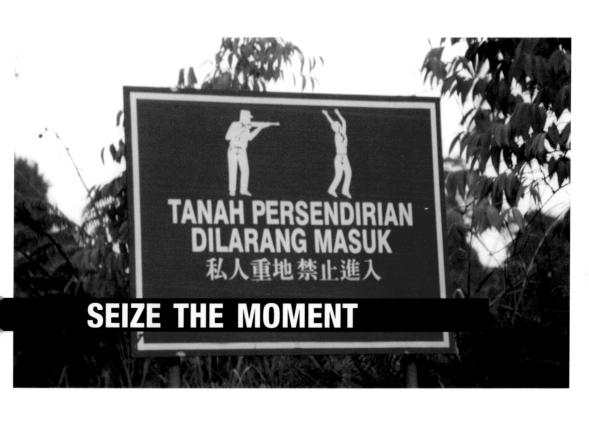

TANAH PERSENDIRIAN
DILARANG MASUK
私人重地禁止進入

SEIZE THE MOMENT

PACK LIGHT

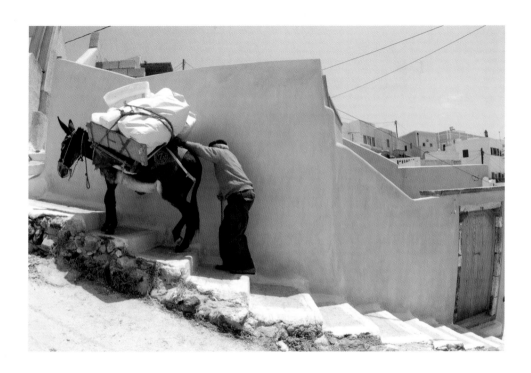

TRY TO GET A
WINDOW SEAT

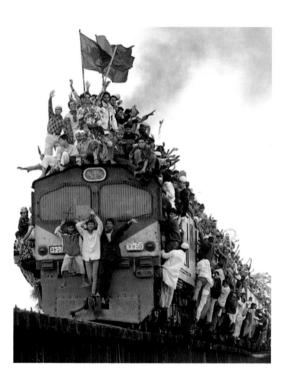

WHEN YOU START TALKING TO YOURSELF, IT'S TIME

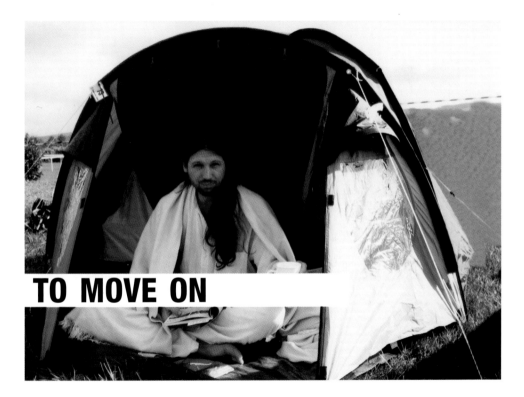

TO MOVE ON

YOU MAY BE STUCK
IN A HOLDING PATTERN

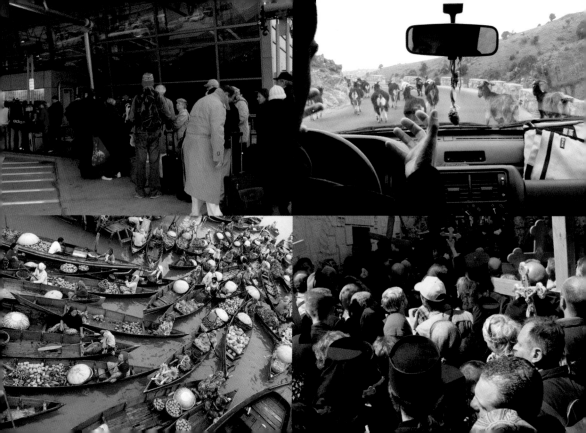

NOT EVERY COUNTRY HAS

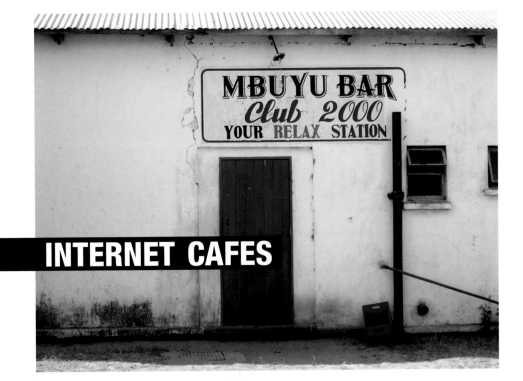

INTERNET CAFES

NOT ALL HOTEL ROOMS FACE THE BEACH

DON'T WORRY, HE'S BEEN
IN THIS LINE OF WORK
FOR SEVERAL...

HOURS...

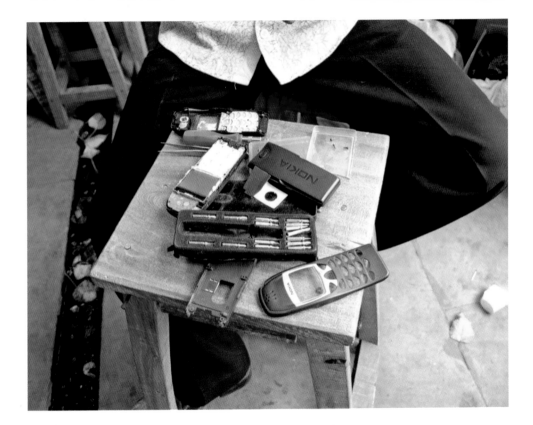

BE WARY OF UNOFFICIAL BANKING INSTITUTIONS

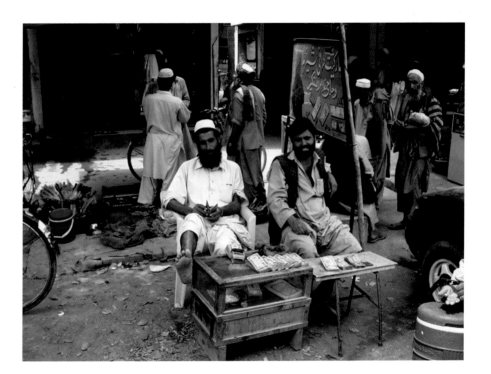

**AT 30,000 FEET
WHAT YOU NEED
IS A PARACHUTE,**

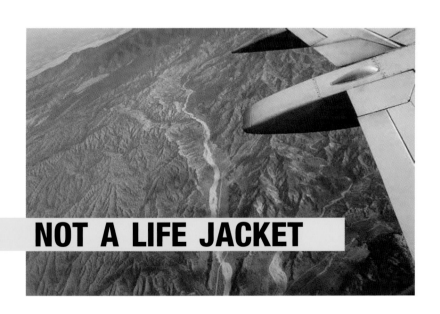

LIMITED BUDGET...

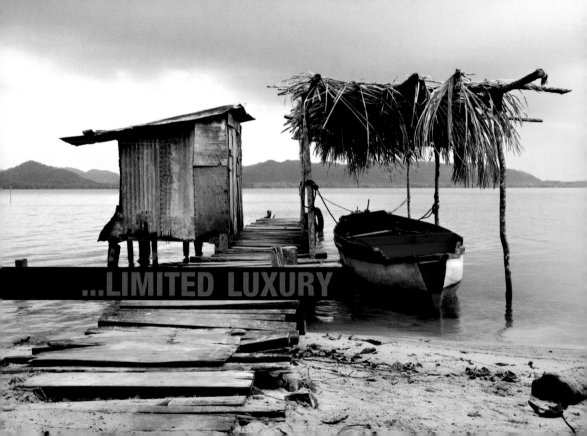

CARRY IDENTIFICATION

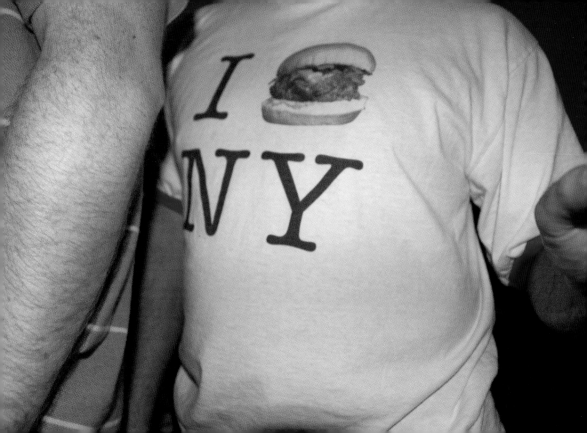

PACE YOURSELF

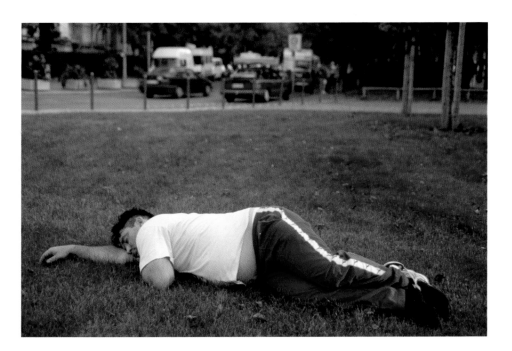

LEARN THE LANGUAGE

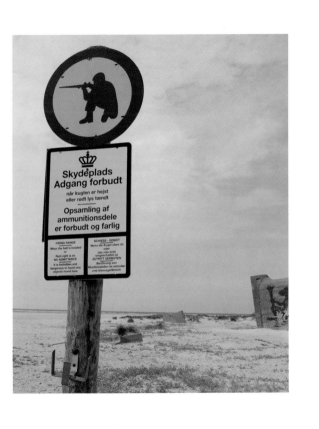

BEFORE YOU RENT A BIKE,

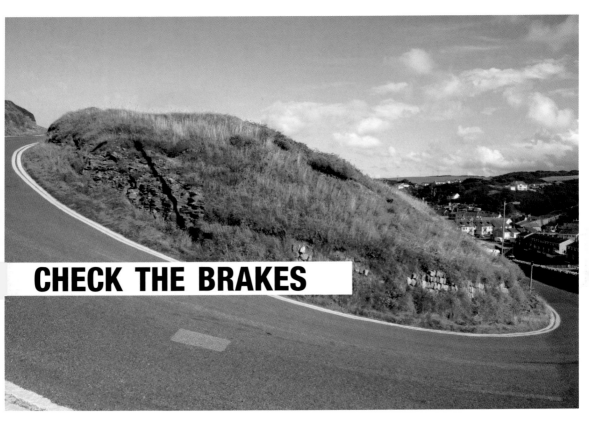

CHECK THE BRAKES

TOURISTS AHEAD,

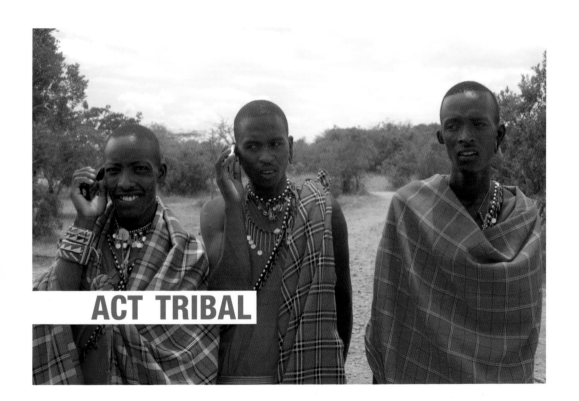

ACT TRIBAL

WHEN YOU SIGN UP FOR A WORKING HOLIDAY IN A FOREIGN COUNTRY...

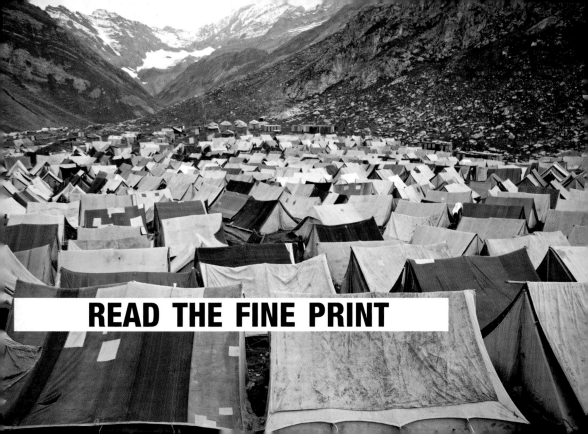

READ THE FINE PRINT

CHERISH THOSE RARE ROMANTIC MOMENTS

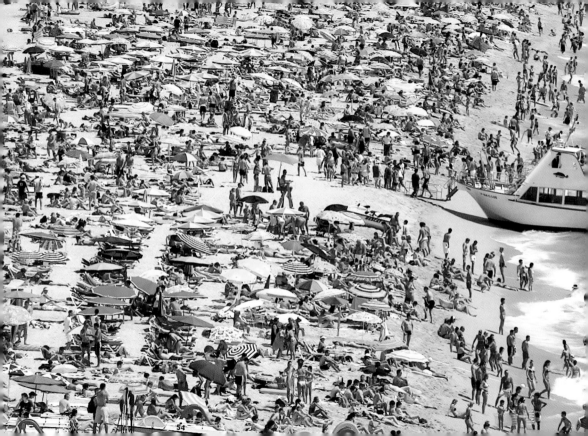

BRING A MAP

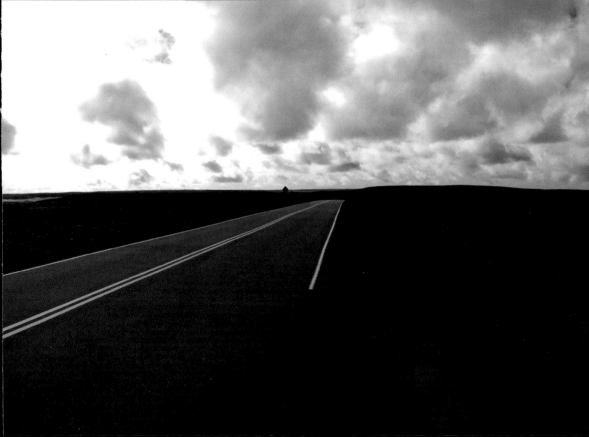

BE UNIQUE IN WHAT YOU DO...
BUT BE AWARE OF

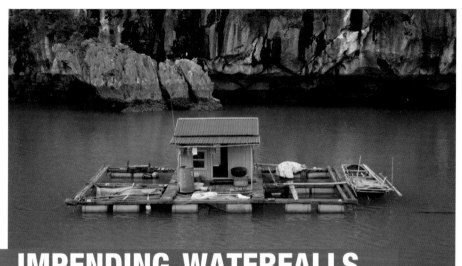

IMPENDING WATERFALLS

THERE MAY BE SITUATIONS WHEN THE CURRENCY IN YOUR VACATIONING COUNTRY IS DEVALUED AFTER A MIDNIGHT COUP; A CURFEW HAS GONE INTO EFFECT AND THE ENTIRE TRANSPORTATION SYSTEM HAS COME TO A COMPLETE HALT; THE AIRPORT IS ENCIRCLED BY TANKS AND YOU ARE TRAPPED IN YOUR HOTEL ROOM. OUR ADVICE TO YOU...

GOOD LUCK

IF YOU ARE HAVING A BAD DAY, POINT THEM IN

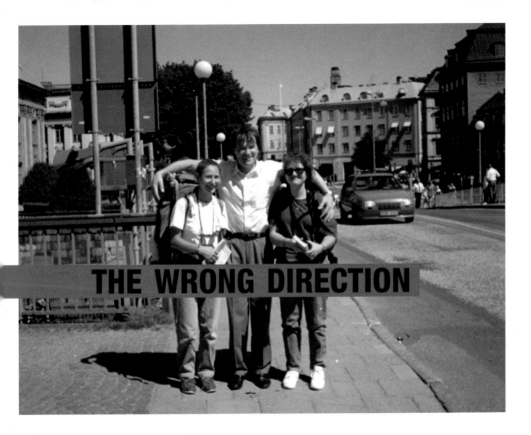

THE WRONG DIRECTION

SOMETIMES
YOU JUST HAVE TO WAIT
FOR THE TRAFFIC

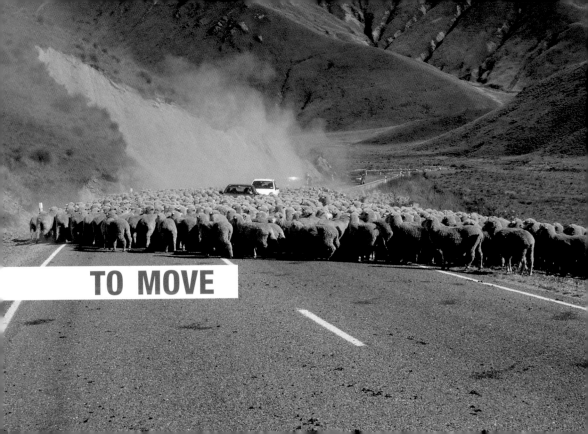

TO MOVE

BRING A SEWING KIT

IT SHOULDN'T TAKE
A LOT OF WOOD
TO ROAST A FEW

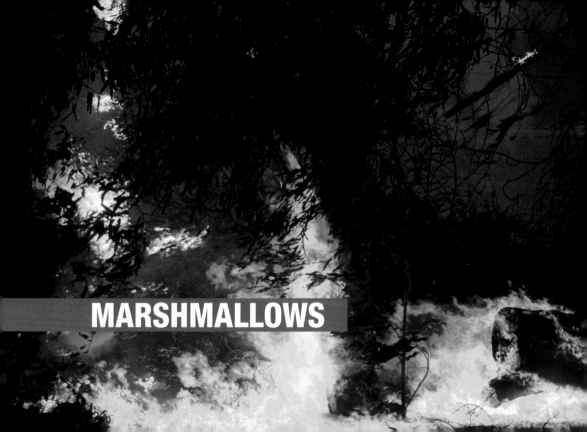

**THE LOCALS
ARE EATING IT
THE LOCALS
ARE DRINKING IT**

**THAT DOESN'T MEAN
YOU SHOULD**

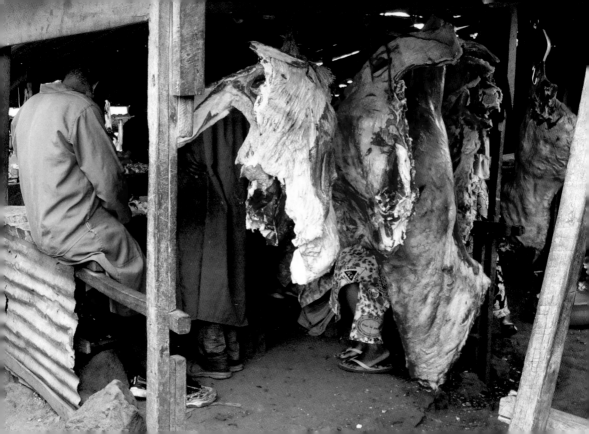

POWER FAILURES CAN OCCUR

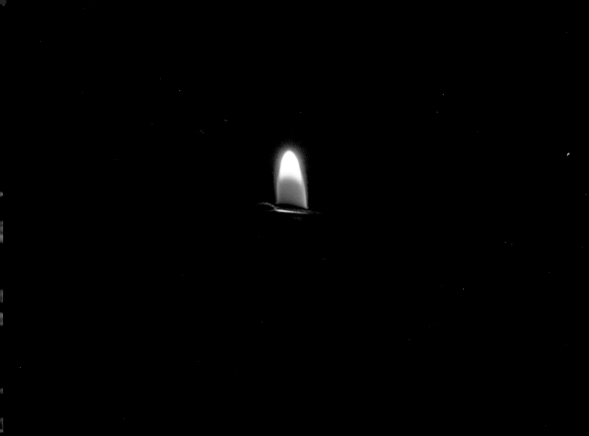

A SIGN MAY SPEAK A THOUSAND DEATHS...

OR BE POINTING TO A PUBLIC LAVATORY

THERE IS ALWAYS THE CHANCE
THAT THE RESTAURANT YOU
READ ABOUT IN YOUR BOOK
HAS GONE BANKRUPT, THE PARK
THAT YOU WANTED TO VISIT IS
INFESTED WITH JUNKIES

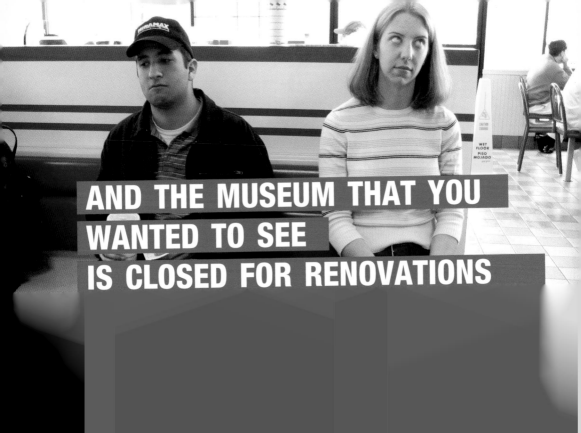

AND THE MUSEUM THAT YOU
WANTED TO SEE
IS CLOSED FOR RENOVATIONS

REMEMBER TO TAKE

A SECOND SET OF
CONTACT LENSES

THERE MAY BE CASES
WHEN CERTAIN FEARS
AND
INSECURITIES CAN IMPEDE
THE ENJOYMENT OF YOUR TRIP...

CLAUSTROPHOBIA, FEAR OF FLYING, CAR SI
OF LYME DISEASE, FEAR OF FOOD POISONI
HYDRATION, FEAR OF SCORPIONS HIDING I
BITES, FEAR OF GETTING KICKED BY A KAN
AND EXPLODING GAS COOKERS, KIDNAPPING
OF LOSING YOUR OFFICIAL IDENTIFICATION
WORSE YET, A GRUNGY TURKISH BATH, FEAR
A PROPER ACCENT, FEAR OF ANTI-WHEREV
SOMEONE WILL MISTAKE YOU FOR THE PR
WALLET, FEAR OF LOSING YOUR SPOUSE, FI
HIND 'BY ACCIDENT', FEAR OF SHARKS IN T

NESS, SEA SICKNESS, AGORAPHOBIA, FEAR
, FEAR OF TRAIN ACCIDENTS, FEAR OF DE
YOUR SHOES, FEAR OF SNAKE AND SPIDER
AROO, FEAR OF SPONTANEOUS CIVIL WARS
ADULT-NAPPINGS AND PICKPOCKETS, FEAR
ND WINDING UP IN A TURKISH PRISON - OR
OF NOT BEING ABLE TO SPEAK FRENCH WITH
R-YOU-CAME-FROM SENTIMENT, FEAR THAT
SIDENT AND SHOOT, FEAR OF LOSING YOUR
R OF LEAVING YOUR SCREAMING CHILD BE-
WAT R – OR WORSE – JELLYFISH. FEAR OF.

IF YOU DISLIKE THE FRENCH...

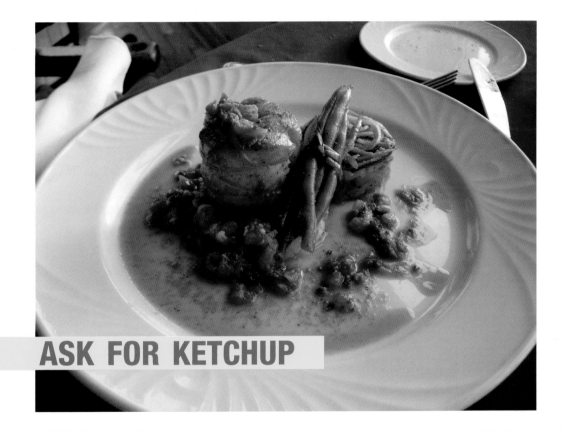

ASK FOR KETCHUP

MOTHER NATURE
IS FUN
UNTIL SOMEONE
GETS BIT

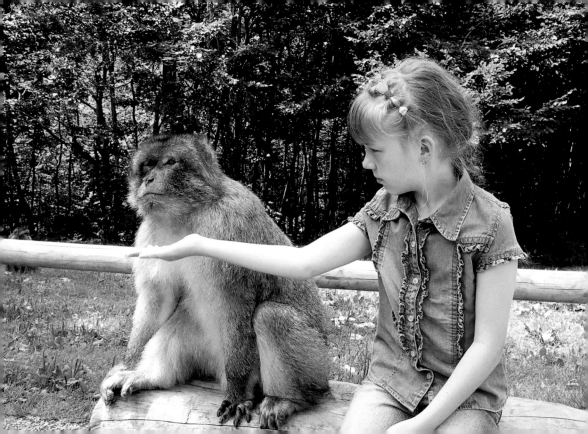

WHEN THE LOCAL SPORTS FIELD ACTS AS THE AIRPORT RUNWAY, PERHAPS IT'S BEST TO SEEK ALTERNATE FORMS OF TRANSPORTATION

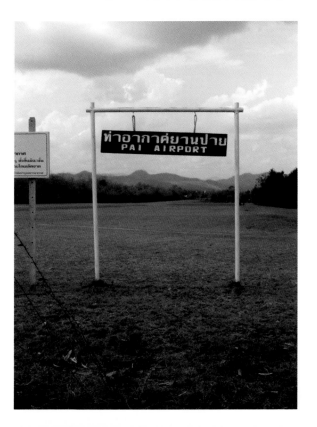

LOSE YOURSELF

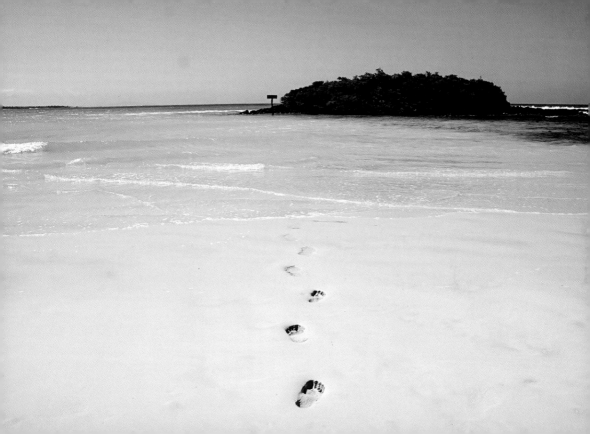

CHECK THE BUILDING CODE STANDARDS

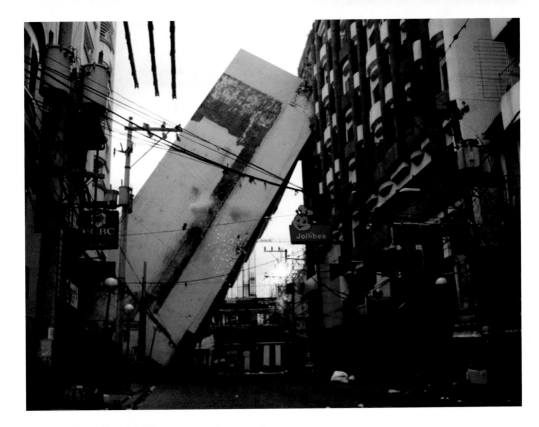

NOT EVERY ESTABLISHMENT
ACCEPTS CREDIT CARDS

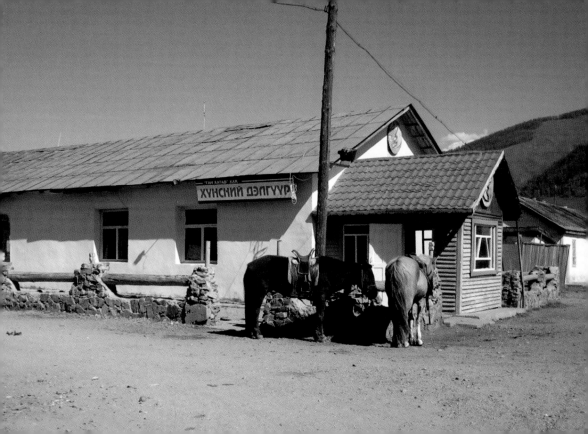

KEEP YOUR CHILDREN AWAKE THE NIGHT BEFORE A LONG DRIVE

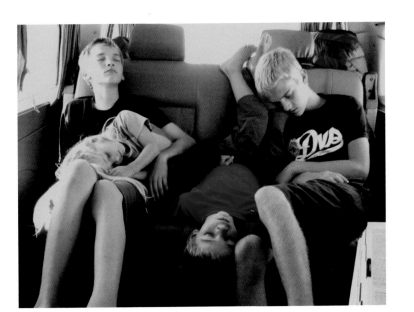

PLAN YOUR TRIP LIKE A MILITARY OPERATION...

YOU ARE, AFTER ALL, INVADING ANOTHER COUNTRY

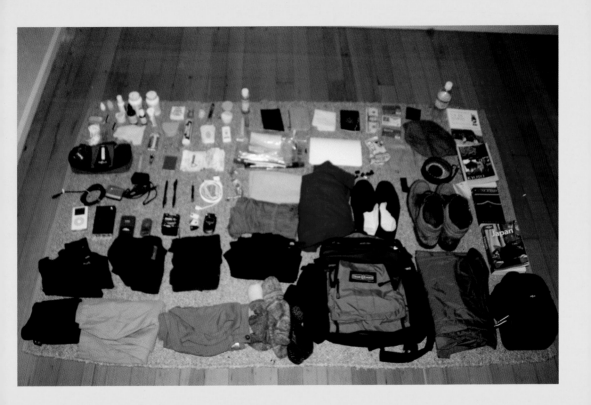

DETOURS MAY BE
TIME-CONSUMING...
ESPECIALLY WHEN THEY

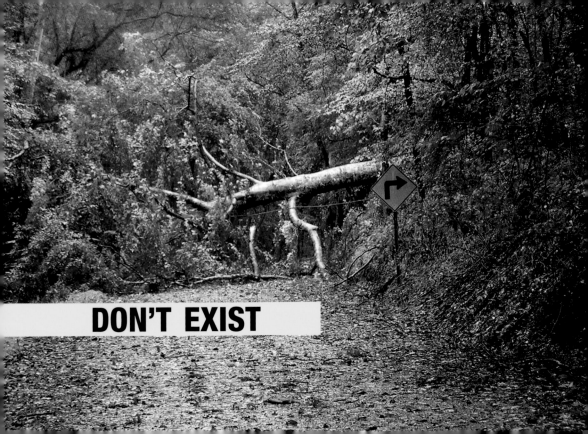

SAY NO TO DRUGS

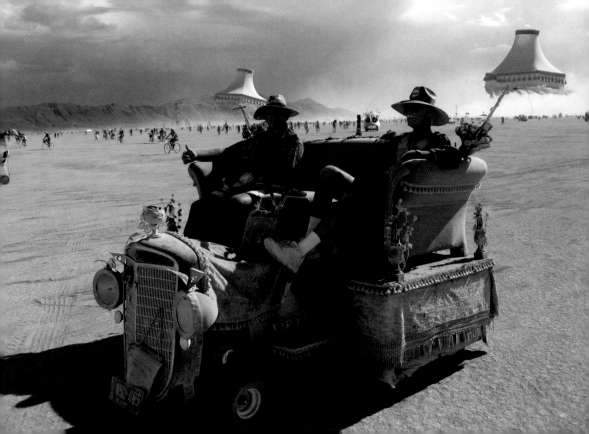

IF YOU FORGOT TO PACK
CERTAIN ITEMS FOR YOUR TRIP...
SUCH AS CLOTHES...

THERE MAY BE OTHER
TRAVELERS IN THE
SAME SITUATION

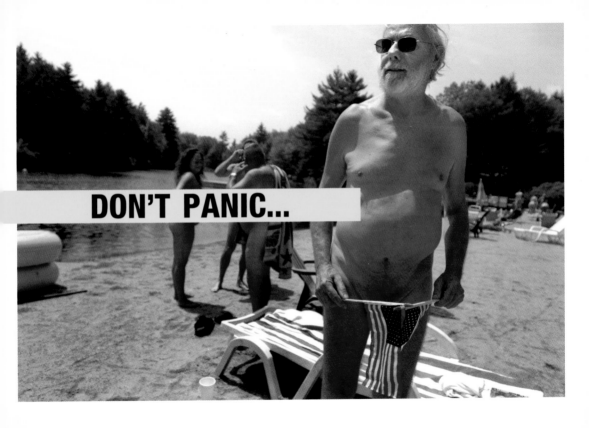

DON'T PANIC...

MAKE SURE YOU GET AN

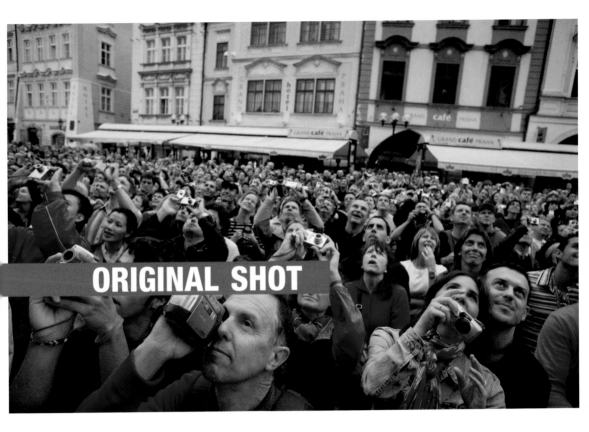

DON'T HITCHHIKE WITH

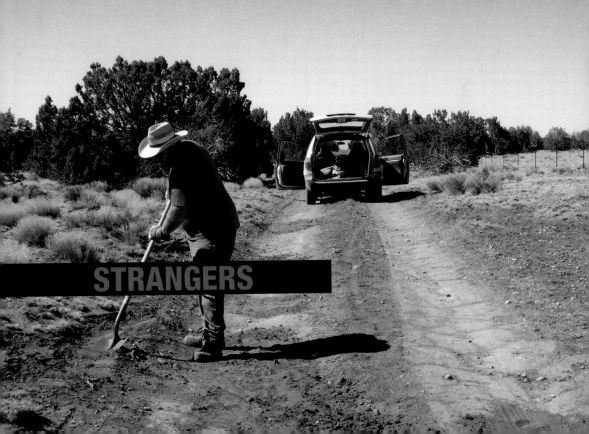

LEAVE YOUR ETHICS AT HOME

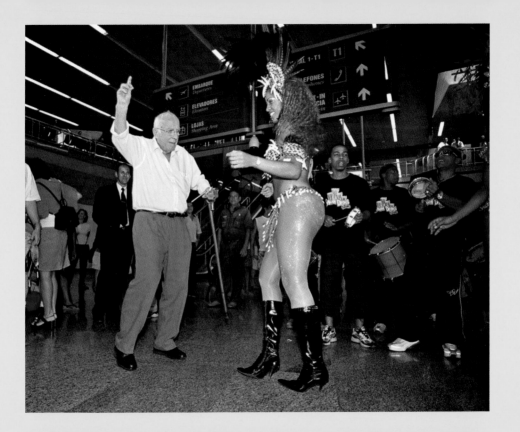

ENJOY

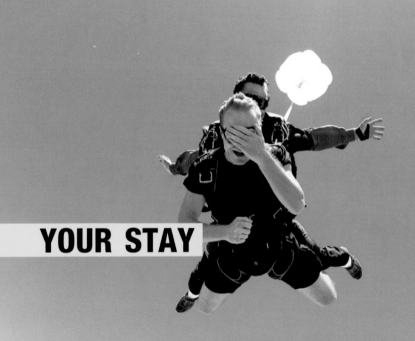

YOUR STAY

These are the people we'd like to thank for the use of their photos in our book – in order of appearance:

Front of suitcase by Staffan Jensen; inside of empty suitcase by Alice Murray; bad weather by Shutterstock; dentist by Liad Blumrosen; laundromats by Claude Renault; brochure lie by Randy Smith; bus schedule by Christine Wagner; modesty by Benjamin Amos; tipping by Stringer Thailand / Reuters; sunburn by Bowlhover at Wikipedia; London driving by Shutterstock; relationships by Joris Postema; civil unrest by Khaled Al Hariri / Reuters; map of A to B by Andy the Hobo Traveler, compliments of HoboTraveler.com, www.hobotraveler.com; overspent by Louke Brands; vehicle safety by C.M. Wasson Co., www.foldabikes.com; different campsites by Chris Ryan Photography; different campers by Matti at www.777-team.org; flotation device by Stephen Wilks www.trojandonkey.net; individuality by Deirdre Straughan www.beginningwithi.com; toilets by Roger J. Wendell;

drinkable water by Shutterstock; pigeons by Marion Hixon; Thai sign by Lee Chai; pack light by Charles Stauffer; window seat by Mufti Munir / Getty Images; talking to yourself by Miranda Stone; holding patterns - airport line by Diane Meyer, inside car by Joris Postema, boats and pilgrims by Shutterstock; internet cafes by Anton Matthee; hotel rooms by Shutterstock; telephone repair by Jan Chipchase; unofficial banking by Gary W. Bowersox; 30,000 ft by Damon Hart-Davis / DHD Multimedia Gallery, http://gallery.hd.org; limited budget by Robert Paetz; carry id by Kate Bryant; pace yourself by Michael S. Yamashita / CORBIS; learn the language by Patrick Dubuc; check the brakes by Shutterstock; act tribal by Julie Ask, Jupiter Research; working holiday by Shutterstock; romantic moments by Shutterstock; bring a map by Shutterstock; be unique by Ray Fleming; good luck by Uriel Sinai / Getty Images; bad day by Charlie Daly; wait for traffic by Terry Nuttall; sewing kit by Alice Murray; marshmallows by Shutterstock; locals are eating it by Khanyan Mehta; power failures by Alice Murray; 1000 deaths by Jan Chipchase; there is a chance by

Special thanks go out to these lovely people:

Yvonne van Versendaal for her graphic and typographic help, for her keen eye and persistence.
Kaisha Projects for researching, chasing, reminding and otherwise sweating it over the photos and releases.
Femke Groot for organizing, managing and working with the support team for releases and extra production issues.
Olivier van Veen, Flora Catsburg and Charlotte Smit, Femke's support team, for their hard work.
And the amazing people at Mark Batty Publisher for making this dream a reality.

Thank you!

Traveler's Advisory
by Jessica Lehrer, Rick Lightstone and Alice Murray

Production Director: Christopher D Salyers
Editing: Buzz Poole

This book is typset in Helvetica, Helvetica Neue, and Times

Library of Congress Control Number: 2007937347

Printed and bound in China by Asia Pacific Offset

10 9 8 7 6 5 4 3 2

Mark Batty Publisher
36 W 37th St, Suite 409
New York, NY 10018

www.markbattypublisher.com

ISBN: 978-0-9795546-3-6

Distributed outside North America by:
Thames & Hudson Ltd
181A High Holborn
London WC1V 7QX
United Kingdom
Tel: 00 44 20 7845 5000
Fax: 00 44 20 7845 5055
www.thameshudson.co.uk